SPARK

a guide to kickstart or reignite your creativity

for introverts, extroverts, and those who have forgotten how to create

Lauren Tyler

Spark

a guide to kickstart or reignite your creativity

By Lauren Tyler © 2018

All rights reserved. Use of any part of this publication, whether reproduced, transmitted in any form or by any means, electronic, mechanical, photocopying, recording, or otherwise, or stored in a retrieval system, without the prior consent of the publisher, is an infringement of copyright law and is forbidden.

While the publisher and author have used their best efforts in preparing this book, they make no representations or warranties with respect to the accuracy or completeness of this book and specifically disclaim any implied warranties of merchantability or fitness for a particular purpose. No warranty may be created or extended by sales representatives or written sales materials. The advice and strategies contained herein may not be suitable for your situation. You should consult with a professional where appropriate. Neither the publisher nor the author shall be liable for any loss of profit or any other commercial damages, including but not limited to special, incidental, consequential, or other damages. The stories and interviews in this book are true although the names and identifiable information may have been changed to maintain confidentiality.

The publisher and author shall have neither liability nor responsibility to any person or entity with respect to loss, damage, or injury caused or alleged to be caused directly or indirectly by the information contained in this book. The information presented herein is in no way intended as a substitute for counseling or other professional guidance.

Print ISBN: 978-1-61206-168-9

eBook ISBN: 978-1-61206-169-6

Production Team: Maryanna Young, Jennifer Regner & Fusion Creative Works

For more information, visit elle-tea.com

Published by

ALOHA PUBLISHING

AlohaPublishing.com

Printed in the United States of America

this is dedicated to the one I love,

mama

Five Things You Will Get From This Book

1. A creative introvert's escape from fear
2. Vulnerability and honesty
3. A beginner bucket list to creative adventures
4. A kickstart to just start creating
5. Love

"It is not in the stars to hold our destiny but in ourselves."

– William Shakespeare

I am an idea creator.

For as long as I can remember, I was coming up with ideas and going through the trial-and-error process.

This all stemmed from two places:
1. I was an only child for 12 years.
2. I read a lot, and I write a lot.

I LOVE falling in deep with a story.
I LOVE creating my own version.

I could never be sent to my room if I was in trouble because that was my sanctuary. It was a reward.

I was also an introvert with big ideas and I was afraid to share them.

(Remember the point about me being an only child?) I had to learn to entertain myself.

I would almost rather be alone than surrounded by people.

It wasn't hard to be me, it was hard to not be like everyone else - to give into peer pressure, to be a typical teenager or student.

I felt like I couldn't connect on a deeper level with most of my peers. I had to pretend to be someone else on the outside than I really was on the inside.

The real me desperately craved to escape.

I *feared* rejection.
I *feared* disappointment.
I *feared* abandonment.

So, I surrounded myself with what I could control.

The older I got . . .
the more I was encouraged by influencers — to *share*, to be *creative*, to be **ME**.

And then I went to college . . .
and something frighteningly wonderful happened —
I was forced to share my work and accept critiques from other people I didn't really know.

That's when the ideas really began to grow. And I learned a few things.

I wanted to be a writer.

BUT...
I also wanted to make movies.
To direct.
To share stories in different ways than on paper.
I wanted to travel.
I **LOVE** live music.
To sing.

I wanted to catalog my days ... what was going on in what I now call my "**portfolio life**." I heard this idea from another writer, Jeff Goins, and was captivated.

And I didn't really care if people praised me or followed me.

I just had this desire to create ideas even if I had no idea how to do most of the things.

So, I started creating lists.

I didn't share them with other people in the beginning. I didn't care if anyone knew what I was doing or what my goals were. I just had to put all these thoughts on paper and out of my head.

I started five different notebooks with one entry each. I had sticky notes all over my purse, computer, desk, and car.

I want to do this. I want to do that.

"If it doesn't work, or I don't really like it, I'll move on," I told myself.

I started reading more books by creatives, reading more blogs from like-minded people I'd never met.

What I found was other people were doing the same thing I was AND they were sharing it with other people.

What I didn't know, until I started sharing my lists, my goals, my adventures, was that there was a world of people in my sphere who were actually listening, waiting, and watching, without me knowing.

They weren't commenting or liking my posts on Facebook or blogs. But they were there.

And when I least expected it, these people came around. To encourage me. To be influencers.

They told me how they followed my adventures online — they lived vicariously through me. What was just my life was encouraging others.

What I was saying or doing just for kicks, just for me, was inspiring others.

Suddenly I had this strange need to **DO MORE**.
Produce more.
Be more.
Be perfect.

Everywhere I went people asked what I was writing. What was I creating?

I set myself up to disappoint . . . them and me.

I came all this way, too afraid to share, and I let real life get in the way. I went back to my old thinking: I didn't have the right connections. I was afraid I would be rejected, afraid that I would never publish a book, never become a writer.

I wouldn't fulfill my childhood dream — be an author.

Then suddenly I wasn't doing it.

I buried the idea.
The desire.

I kept telling myself: one day.
Someday.

And that day came — which is why you are reading this.

I began sitting on the sidelines and taking in all the pep talks possible.

My idea lists grew.

I turned 30 and I put myself out there for everyone to follow and read about. I created 30 things I wanted to do before I turned 31.

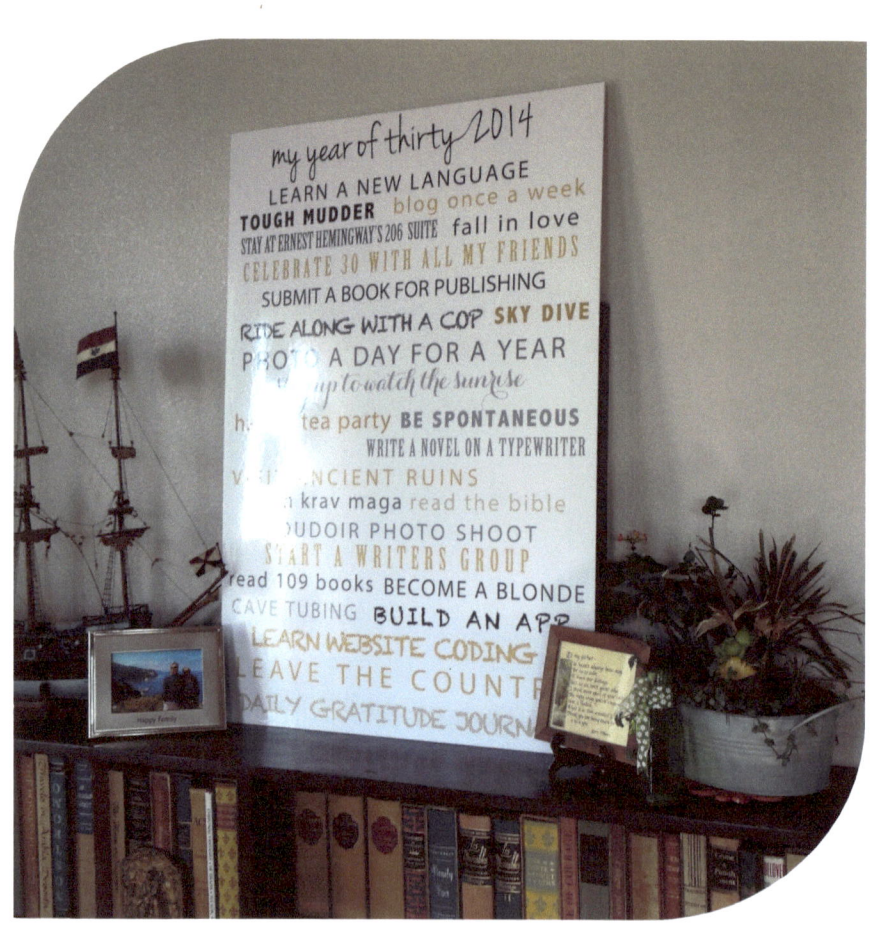

spark: a guide to kickstart or reignite your creativity

1. Ride along with a cop
2. Participate in a boudoir photo shoot
3. Celebrate 30 with all my friends
4. Stay in Ernest Hemingway's Suite 206 in Sun Valley, Idaho
5. Be spontaneous
6. Get my first bikini wax
7. Become a blonde (again)
8. New adventures: flyboarding in Belize, suspended ropes course, six-mile YMCA trail run at Bogus Basin, swimming with sharks, Slide the City, Cupid Undie Run in February, two sprint Triathlons, skinny dipping
9. Leave the country for the first time: Belize
10. Visit ancient ruins
11. Take a jungle boat tour
12. Stay up to watch the sunrise
13. Learn a new language: Italian!
14. Host a tea party
15. Read the Bible in full for the first time
16. Set a record for the number of concerts/bands in a year (25 bands)
17. Read 109 books
18. Write a novel on a typewriter
19. Participate in a flash mob
20. Finish NaNoWriMo
21. Attend an interactive Rocky Horror Picture Show
22. Blog once a week
23. Produce my first wedding video
24. Write 365 thank yous
25. Learn website coding
26. Take a photo a day for a year
27. Contribute to my daily gratitude journal
28. Submit a book to a publisher
29. Fall in **LOVE**
30. Be **BOLD**

I submitted my first book to a publisher.
Yes, I got rejected.

But I found me again. The real me.
And I found others doing just the same thing.

I found I had to **LOVE** me, accept me first, before anything else.

This manifesto is my journey, my encouragement to every creator, idea generator, writer, **LOVER**, dreamer, and friend.

We will *fall*.
We will *struggle*.
We will *fail*.

We get stuck with ideas but no time, no motivation, no idea how to start.

If this has ever been you, yesterday, today, or sometime in the future, know that it can all change.

If you want something, you can have it.

If you have a dream or a goal, it can be achieved.

It might take 20 years, but it can happen.

I don't create lists of goals and ideas for recognition.

I do it because when I die I want to know I lived a full life.

If I stopped — which has happened a few times — it's because I forgot me.

I felt like a piece of me was missing. I let other things get in the way because I thought that's what I was supposed to be doing.

<u>A limb was missing.</u>

Now, from the time I wake up, whether 2 a.m., 5 a.m., or 9 a.m., I already have lists going — the idea of the day.

I don't follow the ways of others even if they are more proven. I like the journey of self-discovery and what ticks for me. My system works for me right now.

I wake up wanting to create.

To share something.

I don't care who is listening.
And I'm not alone and neither are you.

If your ideas only go into a journal to start, then you are STARTING.

If you look at it each day, add to it, cross things off, share one or two, you are on the journey.

If you take an idea and make it public, you are finishing, publishing, acting, and inspiring.

We may never see a direct result of something we created.

It could be five years or five minutes to see the impact.
But it is there.

If we wait, the butterfly effect waits.

This is the pep talk I hear from others — people I know and people I don't.

It's the pep talk I tell myself every morning.

DO SOMETHING!

And it's the one I share with you:

Write 50 words.
Share one idea.
Create something.
Say it out loud.
Make a list.

Do something
EVERYDAY
that touches on your purpose, your goal.

Be there for someone.
Give them an idea.
Spark.
Be a light.

Listen.
Show up.

And don't expect anything in return.

Do it because not doing it isn't an option.
Because we have to share and create.
If we didn't, we WOULDN'T be us.
We'd be hiding something amazing.

Even if we're afraid.
Even if we're tired.
Even if no one is listening.
Even if no one commented or praised you.
Even if no one is holding you accountable.
Even if you'll throw it in the trash later.

Someone is always there behind the scenes waiting to see what you do.

BUT doing it for you is a better feeling than doing it for anyone else.

<3,
Lauren

SPECIAL THANKS

(to most I know and some I've never met)

To my parents (Carla, Larry & Doug) for being my biggest fans since I wrote my first story on paper in fourth grade. For constant encouragement, confidence, and never being annoyed at me for just walking in the front door unannounced, with a new idea.

To Clinton for being my guinea pig and first reader.

To Ronda Conger for pushing me, encouraging me, and sharing her wisdom and insight. For telling me to "just ship it already" and introducing me to the wonderful team at Aloha who made this book possible.

To Jeff Goins for teaching me about the portfolio life and inspiring me to write my manifesto.

To the Aloha Team for taking a chance on me and making my childhood dream come true.

To the books I've read for silently encouraging me to tell my own tale, "steal like an artist," and fill me with ideas, hopes, goals, manners, and entertainment.

ABOUT THE AUTHOR

Lauren Tyler is a digital content librarian by day and a side hustler by night. She writes, creates, and shares all day long.

Born and raised in Boise, Idaho, Lauren has a deep connection with her community and even more with the people she surrounds herself with.

Her cat, Pantoufle, lets her rent a room in his house and likes to snuggle while she drinks an obscene amount of hot tea and looks forward to a glass of wine in the evening while they read books.

Lauren's next adventure is just around the corner.

Connect with Lauren:

Website and Blog :: www.elle-tea.com
Facebook :: @laurentylerauthor
Instagram :: @blondierocket
Twitter :: @blondierocket
Goodreads :: www.goodreads.com/laurenctyler
Medium :: @laurenctyler

www.ingramcontent.com/pod-product-compliance
Lightning Source LLC
Chambersburg PA
CBHW041317180526
45172CB00004B/1136